gathered
VISIONS

Selected Works by African American Women Artists

Robert L. Hall

Published for the
Anacostia Museum of
the Smithsonian Institution
by the Smithsonian Institution Press
Washington and London

For permission to reproduce photographs
appearing in this book, please correspond
directly with the author or with the owners of
the artworks listed in the exhibition checklist.
The Anacostia Museum does not retain
reproduction rights for photographs included
in this publication.

Anacostia Museum
Smithsonian Institution
1901 Fort Place, S.E.
Washington, D.C. 20020

Library of Congress Cataloging-in-Publication
Data
Hall, Robert L., 1950–
Gathered visions: selected works by African
American women artists / Robert L. Hall.
p. cm. ISBN 1-56098-106-7 (pbk.)
1. African American art–Washington
Metropolitan Area–Exhibitions.
2. African American women artists–
Washington Metropolitan Area–Exhibitions.
I. Anacostia Museum. II. Title.
N6538.N5H26 1991
704'.042'09753074753–dc20 91-52846

Published on the occasion of "Gathered Visions:
Selected Works by African American Women
Artists," an exhibition at the Anacostia Museum
from November 18, 1990, to April 28, 1991.

Catalog design: RCW Communication Design Inc.
Catalog editor: Ann Hofstra Grogg
Cover: *Field Trilogy,* sewn fabric by
Viola Burley Leak
Photo credits: Guy C. McElroy, page iv,
Bill Snead (*Washington Post*); all other
photographs by Harold Dorwin (Anacostia
Museum)

CONTENTS

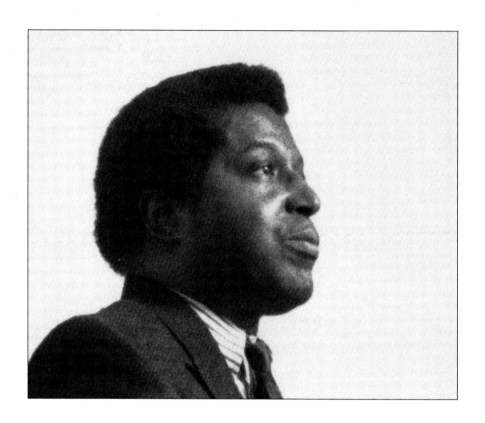

Guy C. McElroy
1948 – 1990

"Gathered Visions" is dedicated to the spirit and memory of historian and curator Guy C. McElroy, who initiated the research for this exhibition.

FOREWORD

"Gathered Visions: Selected Works by African American Women Artists" has provided the Anacostia Museum with another opportunity to give voice to the richness of the African American artistic traditions in the greater Washington area. We are deeply grateful to the participating artists for their collective and individual creativity. Individually, the works display many styles, media, and messages. Together, they form a powerful and moving tribute to the often ignored talents of African American women artists. We cannot allow the perils of racism and sexism to continue to exclude such integral visions and voices from our discussions of African American and American art.

"Gathered Visions" is by no means a comprehensive examination of African American women artists in metropolitan Washington. It is, instead, a lively survey that we hope will provoke further discussion and create the demand for more exhibits. We hope that it is the beginning of a process through which the role of African American women artists in Washington is placed in proper historical and cultural perspectives.

Certainly the exhibit confirms the wisdom of our decision to focus our research, exhibition, and collection activities on Washington, D.C., and the states of Maryland, Virginia, North Carolina, South Carolina, and Georgia. A fertile ground for African American history and cultural activity, this region is home to a treasure trove of documents, artifacts, and works of art. "Gathered Visions" is a perfect example of the richness of this regional focus.

The exhibition of works by fifteen dynamic and dedicated women artists has also given us a chance to explore a variety of issues. Their work looks at the environment, spirituality, birth, home, and community. These sister-artists have shared not only their works but their talents; they have taught, demonstrated, and lectured. They have become a part of the Anacostia family as well as the Anacostia tradition in African American art.

Since 1968 the museum has hosted a number of exhibits focusing on African American art. One of the most notable was the Barnett-Aden Collection exhibit in 1974. "Gathered Visions" encourages us to do more. We have learned that art can serve as a vehicle for greater understanding of our unique community. With the help of people like those who allowed us to gather their visions for this exhibit, we are assured of being able to bring vibrant and meaningful art to our patrons and supporters.

We acknowledge with deep thanks the work of the Anacostia Museum staff for their efforts in making this exhibit a reality. Particular appreciation is given to Robert L. Hall of the museum's education office for continuing the project after the untimely death of Guy C. McElroy. Robert's dedication and experience as a curator of other art exhibits enabled him to bring to fruition this significant and, to our institution, fitting focus on contemporary art.

Steven C. Newsome
Director, Anacostia Museum

v

ACKNOWLEDGMENTS

The museum acknowledges, with appreciation, the research of the late historian Guy C. McElroy (1948–1990), who initiated this exhibition. Assisting him in his work were Yvette Parker and Janet Levine. Thanks is extended to Professor David C. Driskell for his suggestions and support. Appreciation is also extended to Bernadette Lee for allowing us to photograph several of the works while on display in the Mayor's Office. In addition, the museum is grateful to Judith Heisley of the Corcoran Gallery of Art and to Bill O'Leary and Bill Snead of the *Washington Post* for providing us with a photograph of Guy C. McElroy.

The staff of the Anacostia Museum was particularly helpful during the development of "Gathered Visions." My gratitude is extended to former Acting Co-Directors James Mayo and Sharon Reinckens for asking me to continue this exhibition following the death of McElroy. Special thanks are due to Zora Martin-Felton for her endorsement and support and to Harold Dorwin for the many photographs taken. Others I wish to credit are Steven Newsome, Pearline Waldrop, Clara Turner Lee, Joanna Banks, Jennifer Kilman, Spencer Brinker, Victor Augustine, Shelia Parker, Cynthia Smith, and Milton Jones. I especially wish to thank Debra Kearse, whose typing services and assistance proved most beneficial during the development of this exhibition and catalog.

R.L.H.

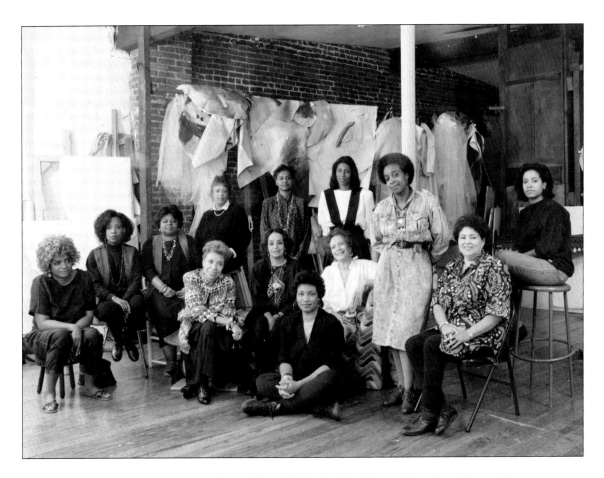

"Gathered Visions" artists First row, from left: Viola Burley Leak (seated on floor), Joyce E. Wellman (standing), Stephanie E. Pogue (seated on chair). Second row, from left: Malkia Roberts, Erlena Chisolm Bland, Lilian Thomas Burwell, Renée Stout (seated on stool). Third row, from left: Sylvia Snowden, Martha Jackson-Jarvis, Adell Westbrook, Margo Humphrey, Yvonne Pickering Carter, Gail Shaw-Clemons. Not shown: Winnie Owens-Hart, Denise Ward-Brown.

INTRODUCTION

As part of its mission for nearly twenty-five years, the Anacostia Museum has provided a place for African American artists to exhibit their works and share their thoughts on creativity with the public. This special relationship continues with the exhibition "Gathered Visions: Selected Works by African American Women Artists."

With "Gathered Visions," the museum expects to further balance the chapter on contemporary art in America, with respect to African American artists in general and to women in particular. It must also be mentioned that the artists whose works are shown here represent a much larger assembly living in the United States. "Gathered Visions," however, focuses on the achievements of some who hold a special place as contributors to the rich visual arts heritage of the metropolitan Washington area.

The relationships of many of the artists to this area run long and stand strong. We find, for example, that six were born in the city and have extended family links. Eleven received formal training from local universities including Howard University, the Catholic University of America, the University of the District of Columbia, and the University of Maryland. In addition to the numerous local galleries that have presented their works, other American, and indeed international, institutions have granted them exhibitions and recognition.

"Gathered Visions" includes fifteen individuals whose visual narratives articulate a multitude of experiences and universal concerns. Events in the life of Denise Ward-Brown, for example, are symbolically expressed through found objects and disassembled furniture, while monotypes created by Stephanie E. Pogue attest to that artist's unabashed sharing of feelings and emotions common to most of us. Comments by Joyce E. Wellman take shape via painted images, metaphors that explain, among other things, human relationships and parental responsibility. To celebrate her pregnancy, Winnie Owens-Hart has created a segmented life-size sculpture that speaks to the importance of that occasion.

It should come as no surprise that the image of the black female, appearing in a variety of stylized forms, serves to facilitate the many messages. A "woman of color" figures prominently in a painting by Malkia Roberts, whereas warnings about the environment by Gail Shaw-Clemons present boldly colored depictions of African American women. In Viola Burley Leak's fabric sculptures, women are integral to her accounts of African American history and often become the story themselves.

Issues concerning families, friends, and their influences are found throughout the exhibition. Printmaker Margo Humphrey spins her special tales about black love and male empowerment with formidable characters that represent the lives and deeds

of those who are close to her. The evocative assemblages of Renée Stout reveal messages about spiritualism and the African legacy and are selectively personalized by objects obtained from relatives and friends. Sylvia Snowden's new direction in painting bears witness to yet another arts tradition in her family — quilting — a craft practiced by her late grandmother, Miss Phoebe.

Works by abstract artists typically allow the viewer to formulate meaning in accordance with personal experience. To this end, Adell Westbrook paints circular shapes of various sizes with supporting rectangular patterns that spring from a color-rich palette. In addition, the selective overlapping of textured and flat geometric shapes by Erlena Chisolm Bland offer a variety of visual options. Complementing the more traditional approaches to creating are several sculptural forms that further define the perimeters of today's art. The installation by Martha Jackson-Jarvis represents her thoughts on traditional healing, while Lilian Thomas Burwell's "environmental exploration" transforms ordinary exhibition space into a statement on nature. Yvonne Pickering Carter adds a slightly different flavor to the show with her costume, adorned door, and multimedia video.

The artists of "Gathered Visions" have joined the ranks of Lois Mailou Jones, Delilah Pierce, Georgette Powell, the late Alma Thomas, and many other African American women who have contributed immensely in spirit and deed to a grand cultural heritage. In turn, those whose works are featured here will no doubt continue to serve the visual arts tradition well with an impressive array of impassioned images.

The Anacostia Museum welcomes the artists of this exhibition and thanks them for being a part of this institution's ongoing efforts to recognize the achievements of African Americans.

Robert L. Hall
Project Director

THE EXHIBITION
▼▼▼▼▼▼▼▼▼▼▼▼▼▼▼▼▼▼▼▼▼▼▼▼▼▼▼▼▼▼▼▼▼▼▼▼

ERLENA CHISOLM BLAND

Painter, sculptor, educator

Erlena Chisolm Bland's improvised colored constructions combine the techniques of sculpture and painting to explore a variety of abstract themes. During the creative process, the artist applies a textured mineral surface to plywood, then cuts these mineral boards into abstract shapes and applies acrylic paint. A third dimension is achieved by her arrangement of these painted shapes, one in front of the other. *Random Abstract* is marked by a starlike design, with a jolting yellow section in the center and panels of contrasting textures. *Dots and Stripes Fornever* makes reference to patriotic symbolism, and Bland embellishes the work by using orange stripes in combination with nontraditional dots. In keeping with the spirit of celebration, she has cut the forms to suggest a rocket.

"Creating art gives me the deepest joy one can ever imagine, and this can be matched only by the pleasure the viewer receives. Creativity resides in the quality of my mind. It originates from my diverse ethnic background and my love of color and shape. These abstract compositions express the underlying spirituality of my being."

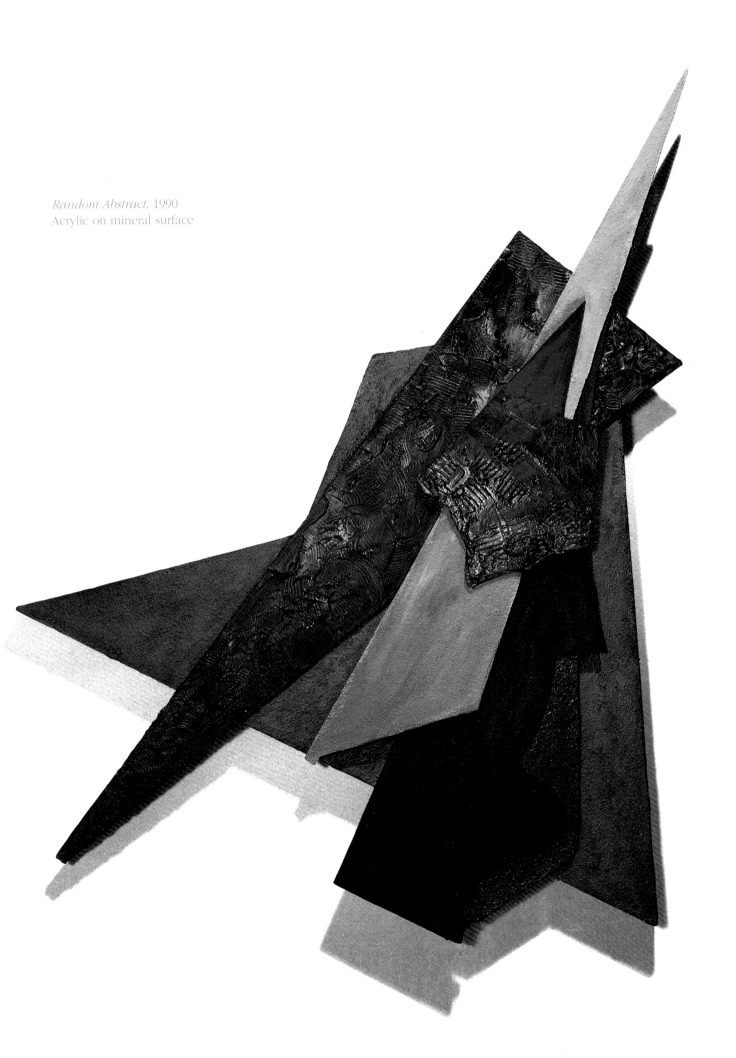

Random Abstract, 1990
Acrylic on mineral surface

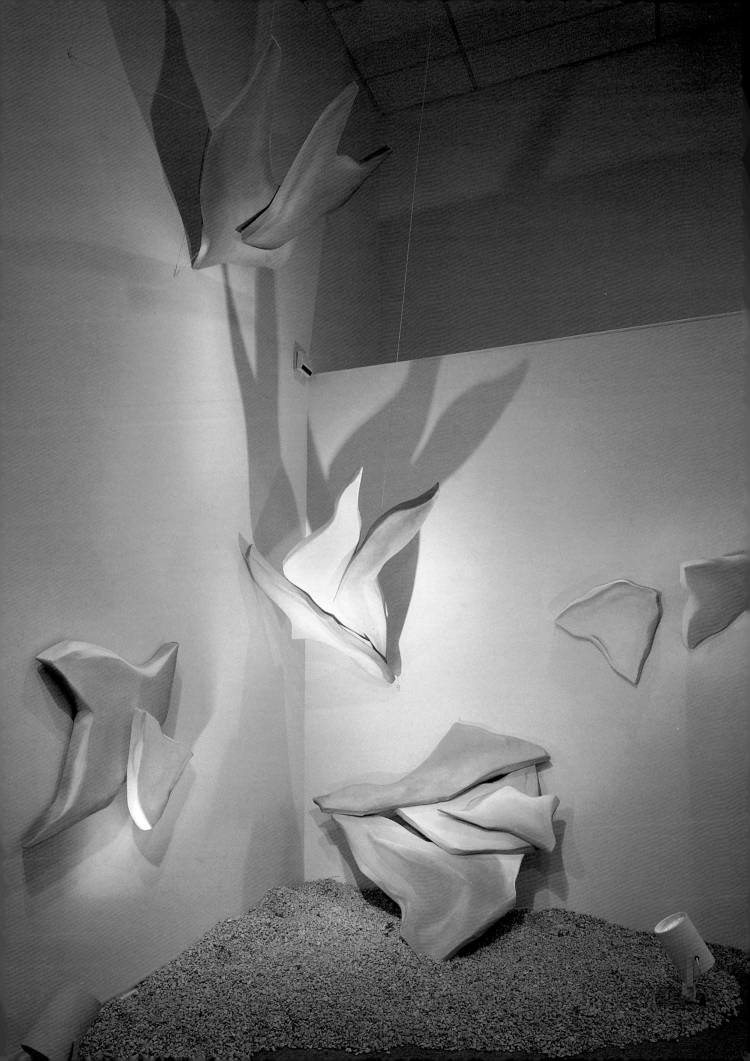

LILIAN THOMAS BURWELL

Painter, sculptor, educator

Lilian Thomas Burwell's *From Passages In and Out of the World* underscores her interest in rocks and other forms found in nature. Three-dimensional, monochromatic canvases are the building blocks of her "environmental explorations." Because Burwell is ever mindful of recycling, formerly completed pieces are sometimes combined with recent paintings to create an entirely new work. For each installation, she studies the specific exhibition space to decide the best approach for her work. These nature-inspired paintings are then strategically assembled to redefine an otherwise ordinary space.

"Whatever you see and feel when you look at my art is part of the making of the art. What you see is *whatever exists in you coupled with whatever exists in me. The result of that equation is the art. Light and shadow play on the canvas-covered surfaces of my wood sculpture. The whispers of paint push the illusion to infer whatever you choose to see."*

From Passages In and Out of the World, 1990
Acrylic on canvas installation

5

YVONNE PICKERING CARTER

Performance artist, painter, educator

Captured on video, *Doors: Entrances, Exits and Trances — Known and Unknown,* is the title of Yvonne Pickering Carter's latest performance art. In the performance, existing doors and those decorated by the artist act as symbols that facilitate the artist's thoughts on the mysteries and complexities of life. *Door XI: Latched,* for example, asks why we harbor secrets. In her multimedia presentation, Carter appears in a costume of her own creation, recites original prose, and moves around and in front of several doors. Also heard in the video are percussion sounds that help to dramatize the occasion.

"Dandelions, wreaths, water, earth, latches, the unknown, expectation, uncertainty, death, and hope are the sources of inspiration for Doors. *"*

Costume for *Doors,* 1990
Acrylic on canvas, fabric, and paper

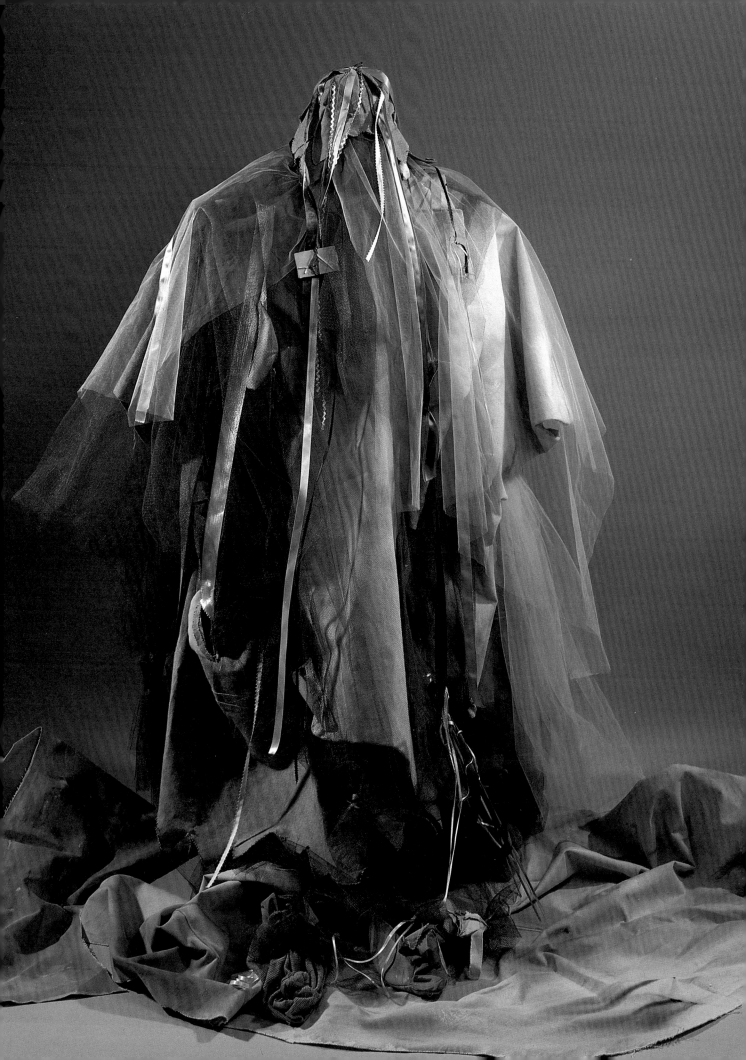

The Last Bar-B-Que, 1989
Color lithograph

MARGO HUMPHREY

Printmaker, sculptor, educator

Typically found in Margo Humphrey's color lithographs are energized elements that comment on contemporary living. The artist combines fantasy images, bold color, and memorable titles to narrate her special tales. In *The Night Kiss/Midnight Rendezvous*, Humphrey allows the viewer to steal a peek at two lovers who seek comfort in the cover of night. *"Lady Luck" Says, Come Take a Chance*, another stylized odyssey, speaks about the importance of taking risks in life and dealing with things as they happen. In *The Last Bar-B-Que*, Humphrey uses a contemporary version of a biblical event to state her support of black male leadership and the sharing of political and economic power.

"The majority of my work is in the narrative form. I use mental and verbal allegories as the basis for my imagery. Within this context I use a palette of intense color to express energy and visual excitement."

MARTHA JACKSON-JARVIS

Ceramic sculptor, educator

Martha Jackson-Jarvis's installation, *Snake Doctor Blue,* offers an expressive view on the power of traditional medicine and spiritual healing. Using clay, she manipulates a functional medium in an architectural manner to address her concerns. Jackson-Jarvis begins with a sketch to solidify her approach but always allows for a certain amount of improvisation during the creative process. The centerpiece of *Snake Doctor Blue* is primarily clay bodies with copper forms, which provide both a structural and a design complement. Smaller forms radiating from the center of the installation echo Jackson-Jarvis's message in star-burst fashion.

"Snake Doctor Blue *is an abbreviation of space in which a view of the conjuring spirit is manifest. It is homage to the 'healers' who work among us, providing medicine for the soul."*

Snake Doctor Blue, 1989
Clay and copper installation

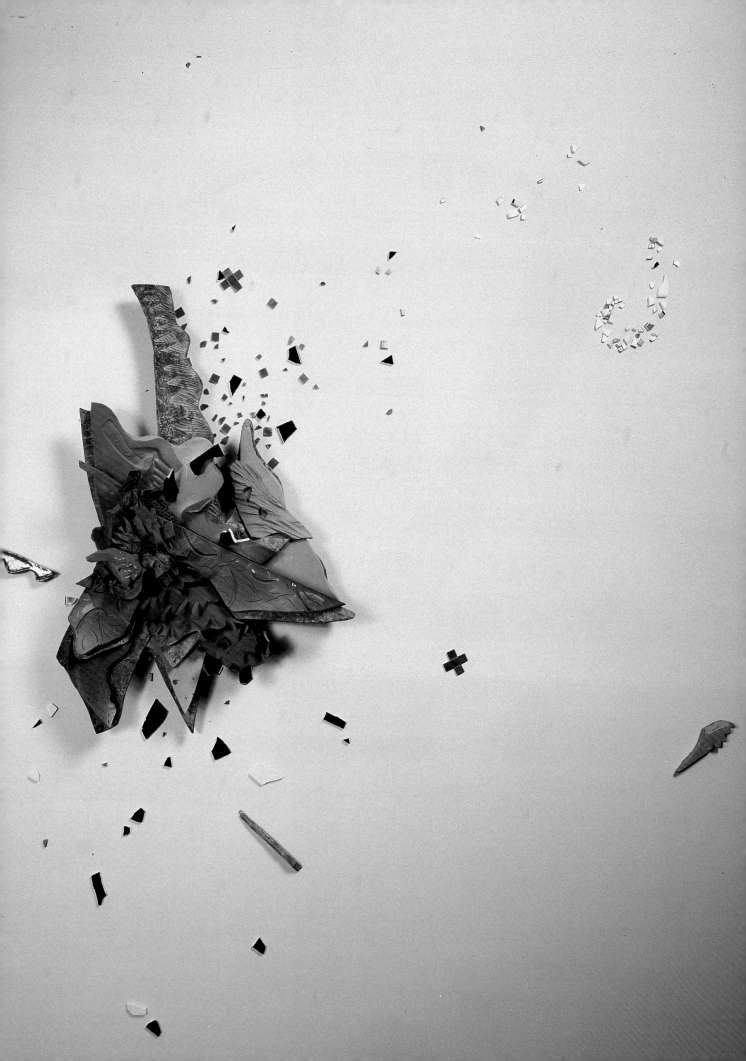

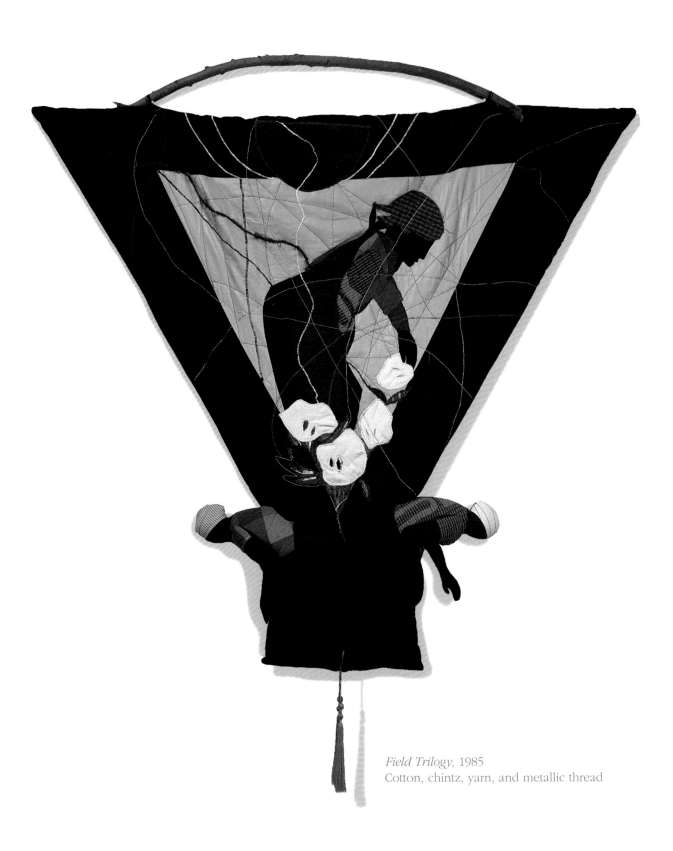

Field Trilogy, 1985
Cotton, chintz, yarn, and metallic thread

VIOLA BURLEY LEAK

Fabric artist, printmaker, educator

Viola Burley Leak gives strong voice to African American history through her sewn fabric works. Scenes from the black experience are generally created at a fast pace as she sews and assembles images by using a wide array of fabrics, threads, and batting material. Cotton pickers are brought to life in *Field Trilogy*, a sculpture that employs the deliberate placement of a black woman flanked by two of smaller size. In *Sunday Sunder*, a nanny shares space with the Birmingham, Alabama, church bombing to show past and contemporary African American events. *Descendants* focuses on a stately female ancestor and other figures to symbolize the survival and strength of African American traditions.

"My work comprises a visual expression of time, circumstances, and myth wrapped into a Black expression. Subject matter is often woven into a complexity of forms, which the viewers are allowed to unweave into their own stories."

WINNIE OWENS-HART

Ceramist, sculptor, educator

Winnie Owens-Hart's ceramic work *Star Four Water Jar* was influenced, in part, by the traditional pottery-making techniques she learned in West Africa. Her clay forms reveal an appreciation for a time-honored creative process and a synthesized design inspired by traditional cultures. In the water jar, she permits the natural color of the clay to be enhanced only by a clear slip, which provides the glossy surface on top. *Trimesters* is a life-size sculpture that commemorates the birth of her daughter. Represented by the three partial torsos are pottery making, swimming, and the final wait.

Trimesters, 1990
Clay

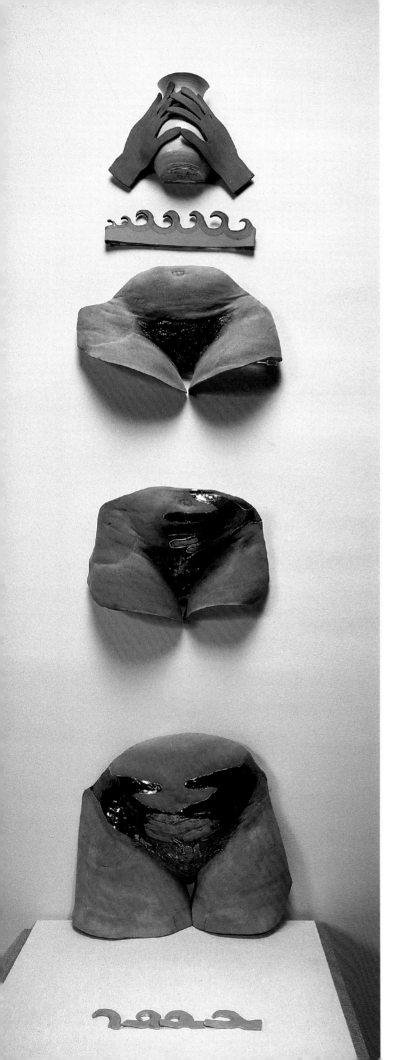

*"A luta continua . . .
(The struggle continues . . .)
— From the Angolan Freedom
Fighters' chant"*

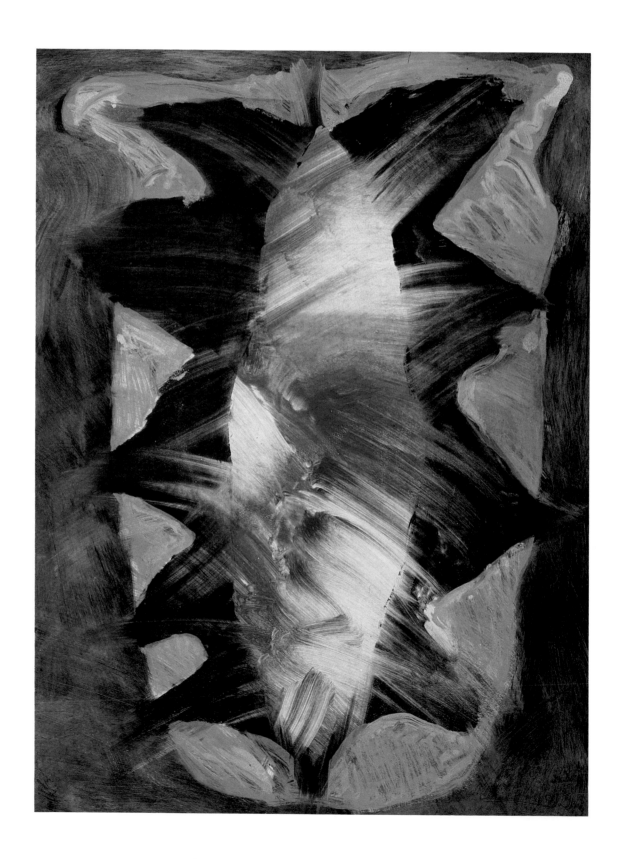

STEPHANIE E. POGUE

Printmaker, educator

While the monotypes created by Stephanie E. Pogue are visual notes prompted by the artist's emotions and experience, they also reflect concerns that are universal — a fear of the unknown, renewed self-awareness, and good feelings. For example, *Self-Portrait: Anxiety* represents a fear of the unknown through the toothy figures that surround and threaten the center image. *Self-Portrait: Discovery*, printed following Pogue's visit to Pakistan and India, is a visual metaphor for learning about new cultures. Discovery is indicated by bold colors and geometric designs that explode from the center of the sheet to the periphery. Symbolic of good feelings in life is *Self-Portrait: Cinnamon Toast*, a heavily textured work depicting a slice of bread flavored with painterly strokes of orange.

"Content has taken on additional layers of meaning as I try to reach inward to the level of my subconscious. My love and exploration of color and texture continue, but the painterly approach, which lends itself so well to the monotype technique, has given me the ability to be freer, more energetic, and more expressive in creating my art."

17

Self-Portrait: Discovery, 1989
Monotype

MALKIA ROBERTS

Painter, educator

Human figures of varying types are commonly found in Malkia Roberts's paintings, but she often develops them into engaging, abstract forms. *Celebrations* shows subtly fashioned dancers and musicians of carnival, an annual event observed throughout most of the West Indies. In the painting the abstract marching figures move through the equally stylized crowd of revelers. *Guardian* features a more clearly defined female figure that peers through a plethora of colors and sweeping brush strokes. To Roberts, "women of color," a current theme, are the protectors of the family and tradition.

"My 'gathered visions' are evoked and implied rather than realistically delineated in the traditional sense. They have evolved and are wedded in patterns of light and color, reflecting my emotional and spiritual reactions to places and 'peoples of color' around the planet, with whom I am bonded. The energy invites viewers to unravel the themes and to come to their own conclusions."

18

Guardian, 1986
Oil and acrylic on canvas

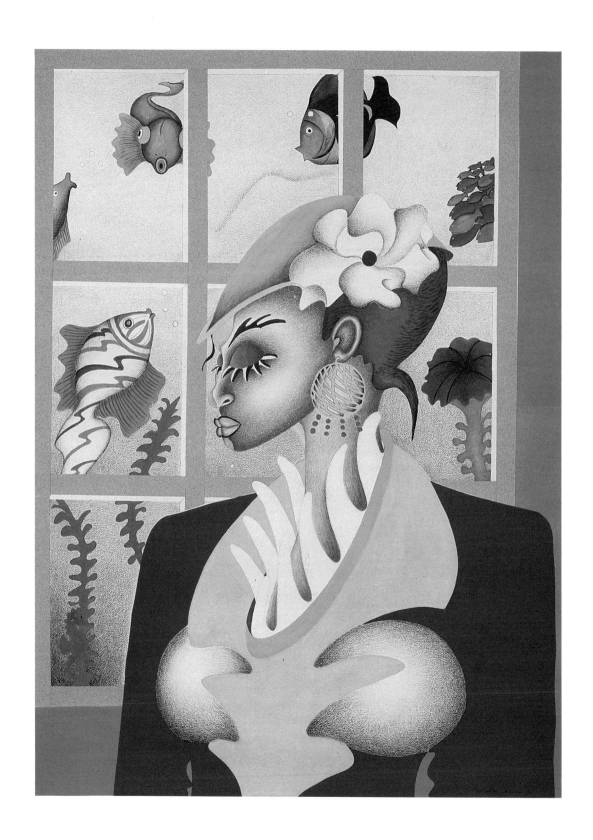

GAIL SHAW-CLEMONS

Mixed-media artist, printmaker, educator

The fantasy figures drawn by Gail Shaw-Clemons express her concern for the earth's environment. *Vital Signs of the City* shows the decay of urban America through a mother-earth figure that melts into the pavement. Her wink offers a dramatic warning about humankind's careless disregard for the city and its resources. A concern about clean air is shown in *Never Take for Granted the Air You Breathe*. In this work a survivor takes refuge in an under-water capsule and thinks about the once-unpolluted skies. The only other visible forms of life are the fish that swim beyond the windows.

"Through my art I feel there is hope, and it is my desire to wake up the world and arouse a more compassionate societal response. Through these fantasies I create dreamlike characters from another place and time with a haunting warning from the future to save our world."

Never Take for Granted the Air You Breathe,
1990
Colored pencil, egg tempera, and collage on paper

SYLVIA SNOWDEN

Painter, educator

Though her recent paintings show a departure from earlier figurative works, Sylvia Snowden's images continue to reflect her own experience. The focus of Snowden's new abstract paintings is the inanimate yet familiar object, the quilt. In *Miss Phoebe's Quilt, I,* the artist pays a tribute to the spirit of her late grandmother, whose favorite pastime was stitching bedcovers from household fabrics. The colors, patterns, and textures found in Snowden's acrylic painting symbolize the many pieces of coats, ties, and dissimilar fabrics Miss Phoebe used in her creations. Dots, stripes, and other patterns recall the various designs present in those early quilts.

"James A. Porter,
Lois Mailou Jones,
James L. Wells,
David C. Driskell

— I paint pictures."

Miss Phoebe's Quilt, I, 1990
Acrylic on canvas

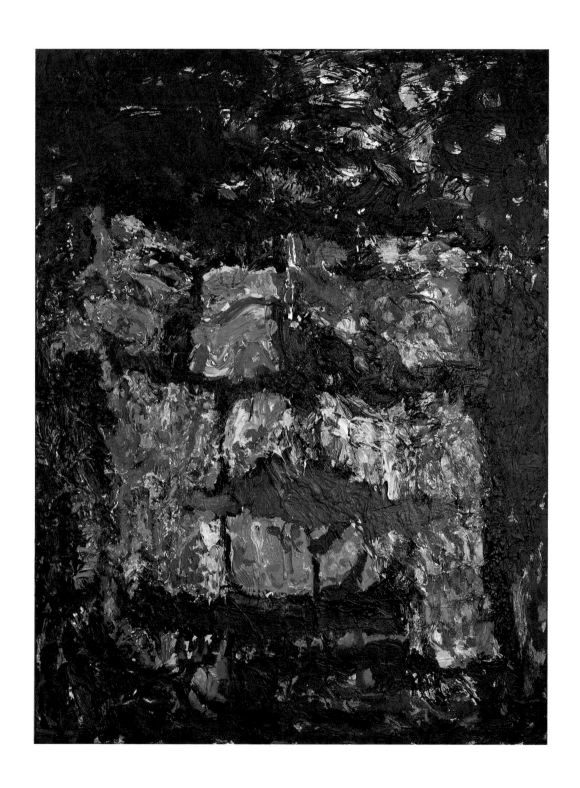

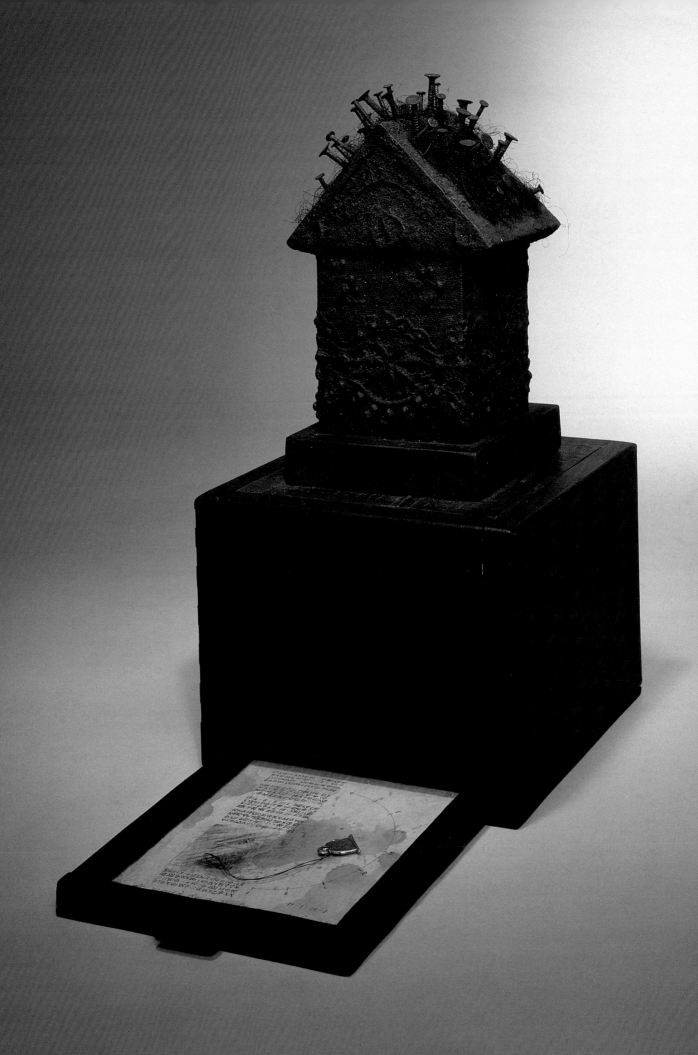

RENÉE STOUT

Sculptor, educator

Renée Stout relies on a personal vision to create especially meaningful mixed-media sculptures. Mystery, spiritualism, death, and whimsy are some of the many themes found in her work. Her "power images," usually dominated by the color black, are made with organic materials, historical items, and objects associated with friends and family. *Spirit House* speaks to the plight of the homeless and comments on Stout's wish that everyone should have a home. The magical intent of traditional African sculpture is recalled in *Exorcising My Demons*, a distinctly contemporary version of the fetish personalized with an assortment of guardian figures. In *The Game*, the artist decided to devise her own system of play that focuses on life's many turns.

"My work has been influenced by African American 'Voodoo' and the African, Native American, and Mexican cultures. All of these cultures are very spiritual. In my work I explore the spiritual in my search for answers to my questions about the human condition."

Spirit House, 1990
Acrylic and dirt on wood, pencil on paper, cotton, and metal

DENISE WARD-BROWN

Sculptor, educator

Found objects, usually broken and sawed pieces of wood, are standard components in the sculpture by Denise Ward-Brown. She transforms pieces of furniture and other structural oddities into mostly abstract statements, prompted to a large degree by events in her life. For example, *Crack in the Sky*, featuring a column that symbolizes the artist's support system, was created to commemorate a turning point in Ward-Brown's life. *Early Spring* represents a transition in style marked by the artist's use of a saw to cut directly into the wood. This upbeat work carries the message that good things are sure to come. In *Kuba Gift*, Ward-Brown was inspired by a visit to a museum showing a collection of centuries-old designs from Central Africa.

"In my sculptures, I use architectural and household 'found' objects (junk) as layers of symbols, forms, found colors, and textures. These human-used objects refer to the history and culture of the previous users. I believe they still hold the energy and beauty of their 'past lives.' My artwork evolves as I research and become inspired by African, African American, and Native American visual and spiritual traditions."

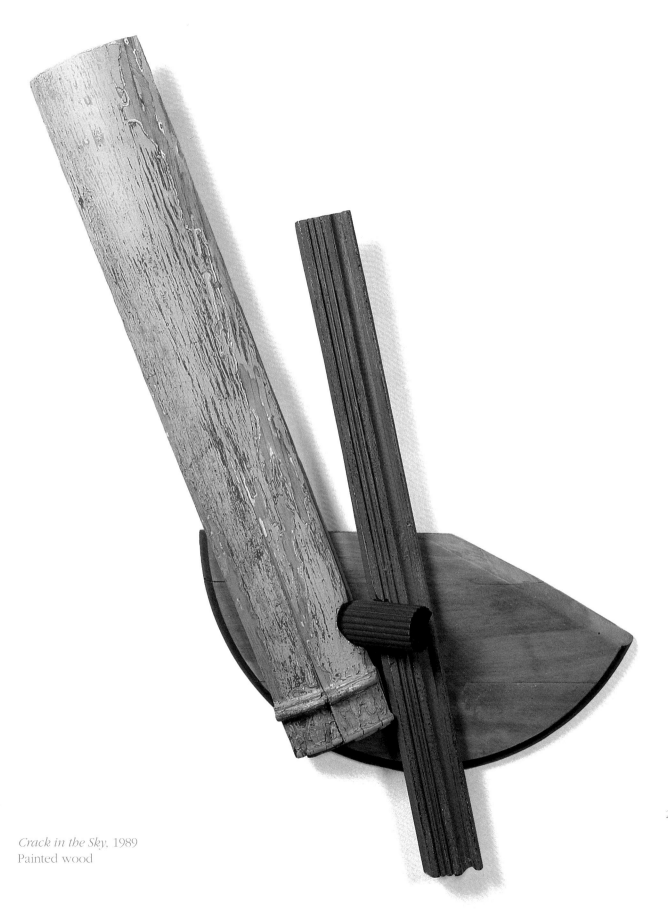

Crack in the Sky, 1989
Painted wood

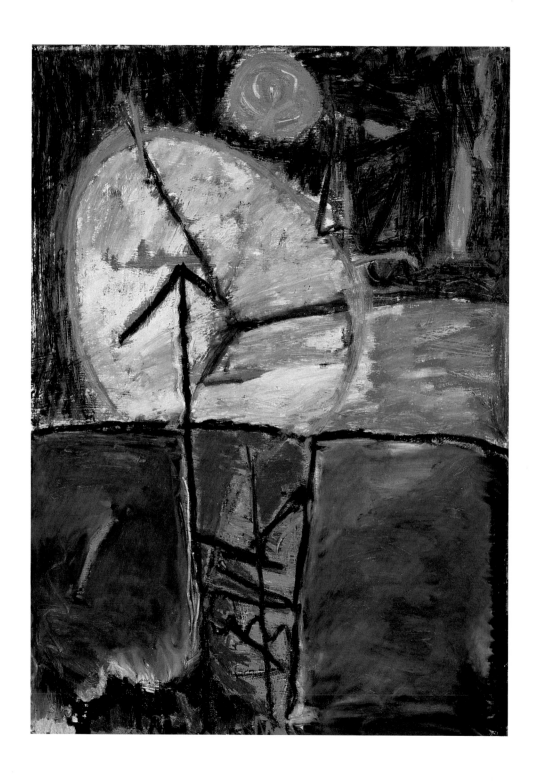

JOYCE E. WELLMAN

Painter, printmaker, educator

Joyce E. Wellman uses figures and animals to address aspects of her life. *Egg on a Leg* expresses her thoughts on parental responsibility through dramatic manipulation of oil paint stick on paper. *Mammal* depicts an undersea creature representing humankind's subconscious and serves as a metaphor for meditation. Wellman has elected to embellish the creature with hair and a goatee to provide a symbolic human connection. Her themes are often self-apparent after the improvised renderings have been completed.

Egg on a Leg, 1989
Oil paint stick on paper

"I have experimented with and evolved a certain set of ideas, images, and symbols through drawings, mixed-media paintings, prints, videos, installation projects, and in collaborations with other artists. The basis of this five-year process has been the use of imagery that reveals itself through color, archetypal forms, cryptic signs, and marks in two-dimensional, multimedia abstract works. The real challenge is to take these freely drawn abstract forms through a process that results in a sensual and visual impact evoking from the viewer an emotional response to these visual stimuli. My intention is to confront the viewer with a vocabulary of archetypal imagery aligned to the nonmaterial and soul force in life."

ADELL WESTBROOK

Painter, educator

Adell Westbrook finds the circle a satisfying shape and uses it in a variety of ways to develop her painted compositions. Though the circle is repeated often in her paintings, its character changes, depending on how she varies the color and size. The acrylic painting *Solar, No. 4* presents an aggressively rendered solar system. Westbrook also selectively places squares and stripes to create visual excitement. In *Untitled, No. 3* she covers the entire surface of the painting by floating her favorite shape.

"The world of art to me includes visual expressions of life experiences. The sciences, music, literature, and travel are all present challenges. My aim is to continue exploring the dynamics of abstract painterly concerns. My work has been described as the juxtaposition of energized color and forms in space."

Solar, No. 4, 1985
Acrylic on canvas

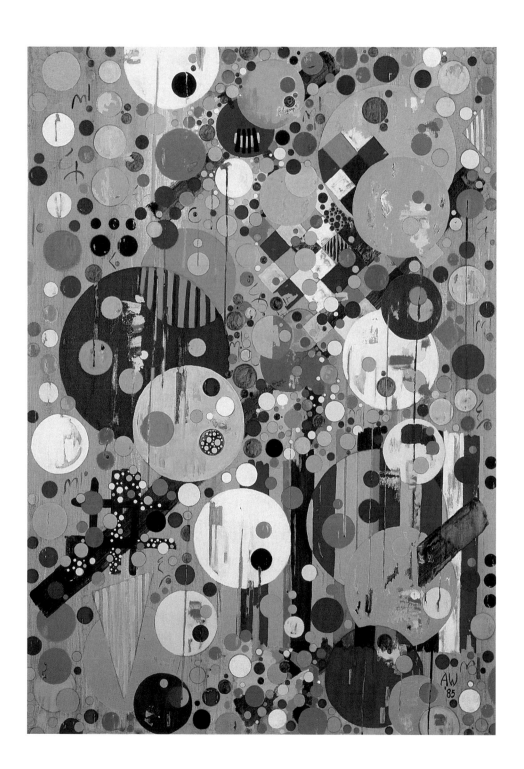

EXHIBITION CHECKLIST
▼▼▼▼▼▼▼▼▼▼▼▼▼▼▼▼▼▼▼▼▼▼▼▼▼▼▼▼▼▼▼▼▼▼▼▼▼

ERLENA CHISOLM BLAND

Random Abstract, 1990
Acrylic on mineral surface
53 x 43½ x 3 in.
Lent by the artist

Dots and Stripes Fornever, 1990
Acrylic on mineral surface
24½ x 15½ x 2½ in.
Lent by the artist

LILIAN THOMAS BURWELL

From Passages In and Out of the World, 1990
Acrylic on canvas installation
150 x 84 x 153 in.
Lent by the artist

YVONNE PICKERING CARTER

Doors: Entrances, Exits and Trances — Known and Unknown, 1990
Performance video
6 min., 39 sec.
Lent by the artist

Costume for *Doors,* 1990
Acrylic on canvas, fabric, and paper
66½ x 86½ x 36 in.
Lent by the artist

Door XI: Latched, 1990
Painted wood, canvas, dried flowers, metal, chintz, and plastic
86 x 39 x 26 in.
Lent by the artist

MARGO HUMPHREY

"Lady Luck" Says, Come Take a Chance, 1985
Color lithograph
22¼ x 30½ in.
Lent by the artist

The Night Kiss/Midnight Rendezvous, 1985
Color lithograph
22¼ x 30 in.
Lent by the artist

The Last Bar-B-Que, 1989
Color lithograph
26 x 38¼ in.
Lent by the artist

MARTHA JACKSON-JARVIS

Snake Doctor Blue, 1989
Clay and copper installation
100 x 108 x 8½ in.
Lent by the artist

VIOLA BURLEY LEAK

Field Trilogy, 1985
Cotton, chintz, yarn, and metallic thread
55 x 47½ x 5 in.
Lent by the artist

Sunday Sunder, 1985
Cotton, silk, satin, and nylon
59 x 19 x 18 in.
Lent by the artist

Descendants, 1985
Cotton, silk, satin, suede, wood, paper, and plastic
51½ x 36 x 7 in.
Lent by the artist

WINNIE OWENS-HART

Star Four Water Jar, 1990
Clay and grass
10 x 9 (diam.) in.
Lent by the artist

Trimesters, 1990
Clay
63 x 18 x 24 in.
Lent by the artist

STEPHANIE E. POGUE

Self-Portrait: Cinnamon Toast, 1989
Monotype
30 x 22½ in.
Lent by the artist

Self-Portrait: Anxiety, 1989
Monotype
30 x 22½ in.
Lent by the artist

Self-Portrait: Discovery, 1989
Monotype
30 x 22½ in.
Lent by the artist

MALKIA ROBERTS

Guardian, 1986
Oil and acrylic on canvas
50 x 42 in.
Lent by the artist

Celebrations, 1990
Oil on canvas
50 x 42 in.
Lent by the artist

GAIL SHAW-CLEMONS

Never Take for Granted the Air You Breathe, 1990
Colored pencil, egg tempera, and collage
on paper
36¾ x 27¼ in.
Lent by the artist

Vital Signs of the City, 1990
Colored pencil and collage on paper
32½ x 27¼ in.
Lent by the artist

SYLVIA SNOWDEN

Miss Phoebe's Quilt, I, 1990
Acrylic on canvas
78 x 60 in.
Lent by the artist

RENÉE STOUT

Exorcising My Demons, 1989
Acrylic and dirt on wood and polystyrene, dried alfalfa sprouts, powdered fungi, corn husks,
paper, plastic, hair, metal, glass, feathers, foil, and bones
36½ x 12 x 6 in.
Lent by the artist

Spirit House, 1990
Acrylic and dirt on wood, pencil on paper, cotton, and metal
11 x 5½ x 5¼ in.
Lent by Clarencetta Jelks

The Game, 1990
Acrylic and dirt on wood, ink and pencil on paper, leather, glass, hair, plastic, foil, bones, metal,
and bugs
20 x 32 x 3 in.
Courtesy B R Kornblatt Gallery, Washington, D.C.

DENISE WARD-BROWN

Crack in the Sky, 1989
Painted wood
43½ x 24 x 5 in.
Lent by Dianne Flannagan Montgomery

Early Spring, 1989
Painted wood and mica
42 x 18½ x 2½ in.
Courtesy Jones Troyer Fitzpatrick Gallery, Washington, D.C.

Kuba Gift, 1989
Painted wood and mica
52½ x 27 x 5½ in.
Courtesy Jones Troyer Fitzpatrick Gallery, Washington, D.C.

JOYCE E. WELLMAN

Egg on a Leg, 1989
Oil paint stick on paper
42 x 30 in.
Lent by the artist

Mammal, 1990
Oil paint stick on paper
42 x 30 in.
Lent by the artist

ADELL WESTBROOK

Untitled, No. 3, 1984
Acrylic on canvas
48 x 48 in.
Lent by the artist

Solar, No. 4, 1985
Acrylic on canvas
50 x 36 in.
Lent by the artist

ARTISTS' BIOGRAPHIES
▼▼▼▼▼▼▼▼▼▼▼▼▼▼▼▼▼▼▼▼▼▼▼▼▼▼▼▼▼▼▼▼▼▼▼

ERLENA CHISOLM BLAND

Painter, sculptor, educator

Born Washington, D.C.

Selected Studies

Howard University, Washington, D.C., B.F.A.

University of Maryland, College Park,
Maryland, M.L.S.

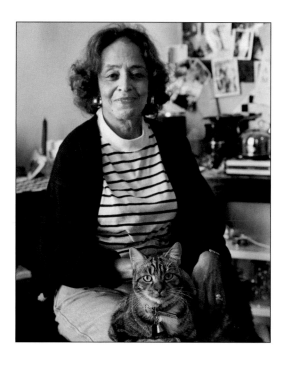

A Selected List

One-Person Exhibitions

Overseas Development Council, Washington,
D.C., 1989

Capitol Gallery, Maryland Parks and Planning
Commission, Landover, Maryland, 1988

Group Exhibitions

Fondo del Sol Visual Art and Media Center,
Washington, D.C., 1990

"Visions 1990," Westbeth Gallery, New York,
New York, 1990

The Bethune Museum-Archives, Inc.,
Washington, D.C., 1989

"Inspiration: 1961–1989," Anacostia Museum,
Smithsonian Institution, Washington, D.C.,
1989

Washington Urban League's 1989 Art Expo,
Washington, D.C., 1989

"Coastal Exchange Show" (traveling
exhibition), Arts Council of Richmond,
Richmond, Virginia, 1988

"14 Washington Women Artists," Evans-Tibbs
Collection, Washington, D.C., 1986

Collections

Bronson, Bronson, and McKinnon Law, Los
Angeles, California

McKay Enterprises, New Orleans, Louisiana

Biographies

Jean Lawlor Cohen, "News and Notes,"
Museum & Arts Washington, May/June 1989

Claire Wilcox, "Washington, D.C.: Mid-Atlantic
Artists' Page," *New Art Examiner*, November
1988

LILIAN THOMAS BURWELL

Painter, sculptor, educator

Born 1927, Washington, D.C.

Selected Studies

Pratt Institute, Brooklyn, New York

The Catholic University of America, Washington, D.C., M.F.A.

A Selected List

One-Person Exhibitions

The "O" Street Studio, Inc., Washington, D.C., 1990

CRT's Craftery Gallery, Hartford, Connecticut, 1988

Group Exhibitions

"African-American Contemporary Art," Museo Civico D'Arte Contemporanea, Di Gibellina, Sicily, Italy, 1990

"Coast to Coast: Women of Color National Artists' Book Project" (traveling exhibition), Baltimore Museum of Art, Baltimore, Maryland, 1990

"Afro-American Art, Now," The George Washington University, Washington, D.C., 1987

"Black Women Visual Artists in Washington, D.C.," The Bethune Museum-Archives, Inc., Washington, D.C., 1986

Martin Luther King Jr. Memorial Library, Washington, D.C., 1985

Museum of Science and Industry, Chicago, Illinois, 1985

Collections

Atlantic Richfield, Philadelphia, Pennsylvania

Parasio, Huelva, Spain

Biographies

Benjamin Abramowitz, "Lilian Thomas Burwell," *Eyewash*, March 1990

Michael Kernan, "Burwell's Breakouts," *Washington Post*, March 1983

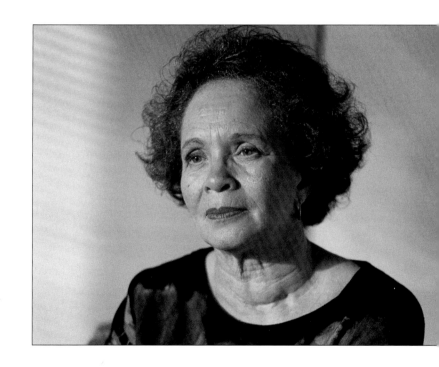

YVONNE PICKERING CARTER

Performance artist, painter, educator

Born 1939, Washington, D.C.

Selected Studies

Howard University, Washington, D.C., A.B., M.F.A.

A Selected List

Group Exhibitions

"African-American Contemporary Art," Musco Civico D'Arte Contemporanea, Di Gibellina, Sicily, Italy, 1990

"Coast to Coast: Women of Color National Artists' Book Project" (traveling exhibition), Baltimore Museum of Art, Baltimore, Maryland, 1990

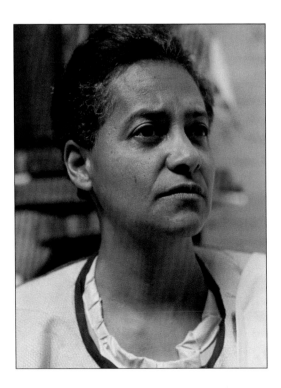

"Introspectives: Contemporary Art by Americans and Brazilians of African Descent," Museum of the Arts, Bronx, New York, 1990

"Celebrate African American Art: Yesterday and Today," Art at 100 Pearl, Hartford, Connecticut, 1989

"Pillar to Post: Wall Works by Contemporary Artists," Kenkeleba Gallery, New York, New York, 1989

Multimedia Performances

"Confessions: The Making of a Sinner or Saint," National Museum of Women in the Arts, Washington, D.C., 1990

"Installation . . . Lament," Walters Art Gallery, Baltimore, Maryland, 1988

"Relic, Ritual, and Region," University of Maryland, College Park, Maryland, 1988

Collections

Carnegie Collection, University of the District of Columbia, Washington, D.C.

Gibbes Art Gallery, Charleston, South Carolina

North Carolina Museum of Art, Raleigh, North Carolina

Biographies

Elizabeth Hess, "Material Nature," *Village Voice*, March 7, 1989

Michael Brenson, "Sculptors Using the Wall as Venue and Inspiration," *New York Times*, February 24, 1989

Allison Gamble, "Mayor's 1988 Black History Art Exhibit," *New Art Examiner*, June 1988

MARGO HUMPHREY

Printmaker, sculptor, educator

Born 1942, Oakland, California

Selected Studies

California College of Arts and Crafts, Oakland, California, B.F.A.

Stanford University, Palo Alto, California, M.F.A.

A Selected List

One-Person Exhibitions

"Lithographs by Margo Humphrey," United States Information Service Gallery, Lagos, Nigeria, 1988

"Prints by Margo Humphrey," The New Art Gallery, University of Nebraska at Lincoln, Lincoln, Nebraska, 1985

Group Exhibitions

"Prints California: North/South," Mills College Art Gallery, Oakland, California, 1988

"Ten Masters," National Conference of Artists Exhibition, Museum da Art Du Bahia, Salvador-Bahia, Brazil, 1988

"Contemporary Perspectives of Afro-American Art," University Art Museum, Arizona State University, Tempe, Arizona, 1987

"Contemporary Print and Drawing Exhibition," Dartmouth College, Hanover, New Hampshire, 1987

"Choosing: Afro-American Art, 1925–1985," Museum of Science and Industry, Chicago, Illinois, 1986

"Works of Art on Paper by Black American Artists," Crocker Art Museum, Sacramento, California, 1986

"Eighth British International Print Biennale," Cartwright Hall, Lister Park, Bradford, England, 1984

Collections

Los Angeles County Museum of Art, Los Angeles, California

The Oakland Museum, Oakland, California

Philadelphia Museum of Art, Philadelphia, Pennsylvania

Biographies

Ramsay Bell Breslin, "Those Who Forgot Her Story," *Express,* February 8, 1991

Michael Brenson, "Examining the Role of the Blues," *New York Times,* September 26, 1989

Clinton Adams, *Tamarind Technical Papers,* 9, no.1, Spring 1986

MARTHA JACKSON-JARVIS

Ceramic sculptor, educator

Born 1952, Lynchburg, Virginia

Selected Studies

Tyler School of Art, Temple University, Philadelphia, Pennsylvania, B.F.A.

Antioch University, Columbia, Maryland, M.F.A.

A Selected List

One-Person Exhibitions

B R Kornblatt Gallery, Washington, D.C., 1989

University Gallery, University of Delaware, Newark, Delaware, 1988

Group Exhibitions

"The Blues Aesthetic: Black Culture and Modernism," Washington Project for the Arts, Washington, D.C., 1989

"Introspectives: Contemporary Art by Americans and Brazilians of African Descent," California Afro-American Museum, Los Angeles, California, 1989

"Contemporary Visual Expressions: The Art of Sam Gilliam, Martha Jackson-Jarvis, Keith Morrison, and William T. Williams," Anacostia Museum, Smithsonian Institution, Washington, D.C., 1987

"Generations in Transition," Museum of Science and Industry, Chicago, Illinois, 1986

"The Other Gods," Everson Museum of Art of Syracuse and Onondaga County, Syracuse, New York, 1986

"Evocative Abstractions," Nexus Foundation for Contemporary Art, Philadelphia, Pennsylvania, 1985

"Washington Sculpture," Georgetown Court Artist Space, Washington, D.C., 1984

Collections

Lenkin Company, Washington, D.C.

Peat Marwick Main & Company, Washington, D.C.

Philip Morris Corporation, Washington, D.C.

Biographies

Lee Fleming, "Myth and Ritual," *Washington Review,* April/May 1986

Jane Addams Allen, "Some New Species from Local Innovator," *Washington Times,* August 11, 1983

Paul Richard, "The Power and the Spirit," *Washington Post,* February 19, 1983

VIOLA BURLEY LEAK

Fabric artist, printmaker, educator

Born 1944, Nashville, Tennessee

Selected Studies

Fisk University, Nashville, Tennessee, B.A.

Pratt Institute, Brooklyn, New York, B.F.A.

Hunter College, New York, New York, M.A.

Howard University, Washington, D.C., M.F.A.

A Selected List

One-Person Exhibitions

Northern Virginia Community College, Annandale, Virginia, 1990

Montgomery College Art Gallery, Rockville, Maryland, 1989

Group Exhibitions

Strathmore Hall Arts Center, Rockville, Maryland, 1989

"The Seventh Atlanta Life African-American National Art Competition and Exhibition," Atlanta Life Insurance Company, Atlanta, Georgia, 1987

"Black Women Visual Artists in Washington, D.C.," The Bethune Museum-Archives, Inc., Washington, D.C., 1986

Dusable Museum of African American History, Inc., Chicago, Illinois, 1984

Hodson Gallery, Hood College, Frederick, Maryland, 1984

Market 5 Gallery, Washington, D.C., 1984

Collections

Atlanta Life Insurance Company, Atlanta, Georgia

Howard University, Washington, D.C.

Manufacturers Hanover Trust Company, New York, New York

Biographies

Lynn M. Igoe, *250 Years of Afro-American Art: An Annotated Bibliography,* 1981

Kurt Wilner, "Given for Good," *Art Direction,* March 1979

Samuel A. Tower, "Stamps: International Women's Year," *New York Times,* April 20, 1975

WINNIE OWENS-HART

Ceramist, sculptor, educator

Born 1949, Washington, D.C.

Selected Studies

Philadelphia College of Art, Philadelphia, Pennsylvania, B.F.A.

Howard University, Washington, D.C., M.F.A.

A Selected List

One-Person Exhibitions

"Dreams, Visions, Nightmares and the Real World," Haas Gallery, Bloomsburg University, Bloomsburg, Pennsylvania, 1988

"Winnie Owens-Hart: An Exhibition of African American Contemporary/Traditional Ceramics," CRT's Craftery Gallery, Hartford, Connecticut, 1983

Group Exhibitions

"Influences: Contemporary African and African-American Art" (curator and exhibiting artist), Hodson Gallery, Hood College, Frederick, Maryland, 1989

"Contemporary Directions in Clay," Columbia Association Center for the Arts, Columbia, Maryland, 1987

"VOICES: An Exhibition of Works by 14 Afro-American Artists," Community Folk Art Gallery, Syracuse, New York, 1987

"Black Women Visual Artists in Washington, D.C.," The Bethune Museum-Archives, Inc., Washington, D.C., 1986

"Biennale Internationale de Céramique d'Art," Vallauris, France, 1984

"Through Women's Hands," Volta Place Gallery, Washington, D.C., 1983

"Forever Free: Art by African-American Women, 1862–1980" (traveling exhibition), Center for the Visual Arts Gallery, Illinois State University, Normal, Illinois, 1981

Collections

Howard University Gallery of Art, Washington, D.C.

Syracuse University, Syracuse, New York

Biographies

Monifa Atungaye, "Winnie Owens-Hart," *Ceramics Monthly,* September 1988

Harriet Jackson Scarupa, "Winnie Owens: Messenger in Clay," *New Directions,* October 1979

STEPHANIE E. POGUE

Printmaker, educator

Born 1944, Shelby, North Carolina

Selected Studies

Howard University, Washington, D.C., B.F.A.

Cranbrook Academy of Art, Bloomfield Hills, Michigan, M.F.A.

A Selected List

One-Person Exhibitions

Castle Gallery, Hyattsville, Maryland, 1989

City Museum, Arondelovac, Yugoslavia, 1985

Group Exhibitions

"Black Women Artists: North Carolina Connections," North Carolina Central University Art Museum, Durham, North Carolina, 1990

Faculty Exhibition, University Art Gallery, University of Maryland, College Park, Maryland, 1990

Black Arts Festival Exhibition, Spelman College, Atlanta, Georgia, 1988

"The Art of Black America in Japan: Afro-American Modernism, 1937–1987," Tokyo and Chiba, Japan, 1987

"International Print Exhibit," Taipei City Museum of Fine Arts, Taipei, Taiwan, 1983

"Directions in Afro-American Abstract Art," The Carl Van Vechten Gallery of Fine Arts, Fisk University, Nashville, Tennessee, 1982

"Forever Free: Art by African-American Women, 1862–1980" (traveling exhibition), Center for the Visual Arts Gallery, Illinois State University, Normal, Illinois, 1981

Collections

Fisk University, Nashville, Tennessee

The Studio Museum in Harlem, New York, New York

The Whitney Museum of American Art, New York, New York

Biographies

Samella Lewis and Bob Biddle, *International Review of African-American Art*, 6, no. 4, 1986

David C. Driskell, "New Works by Stephanie Pogue," *American Literature Forum*, 19, no. 1, Spring 1985

MALKIA ROBERTS

Painter, educator

Born Washington, D.C.

Selected Studies

Howard University, Washington, D.C., B.A.

University of Michigan, Ann Arbor, Michigan, M.F.A.

A Selected List

One-Person Exhibitions

"Awake the Echoes," Gallery Antigua, Miami, Florida, 1988

"Odyssey: Paintings by Malkia Roberts," King-Tisdell Cottage, Savannah, Georgia, 1987

Group Exhibitions

"Influences: Contemporary African and African-American Art," Hodson Gallery, Hood College, Frederick, Maryland, 1989

"Black Women Visual Artists in Washington, D.C.," The Bethune Museum-Archives, Inc., 1986

"Afro-American Abstract Artists," Evans-Tibbs Collection, Washington, D.C., 1986

"Through Women's Hands," Volta Place Gallery, Washington, D.C., 1983

"Verve!" Nyangoma's Gallery, Washington, D.C., 1982

"An Exhibition by Faculty Painters," Northern Virginia Community College, Annandale, Virginia, 1982

"The Second Atlanta Life African-American National Art Competition and Exhibition," Atlanta Life Insurance Company, Atlanta, Georgia, 1982

Collections

Atlanta University, Atlanta, Georgia

Evans-Tibbs Collection, Washington, D.C.

Biographies

Samella Lewis, *Art: African American*, 1978

Edward J. Atkinson, *Black Dimensions in Contemporary American Art*, 1971

GAIL SHAW-CLEMONS

Mixed-media artist, printmaker, educator

Born 1953, Washington, D.C.

Selected Studies

University of Maryland, College Park, B.A., M.F.A.

A Selected List

One-Person Exhibitions

"Art Reach Milwaukee" (traveling exhibition), Milwaukee, Wisconsin, 1988

Tera Rouge Gallery, Milwaukee, Wisconsin, 1988

Group Exhibitions

Alex Gallery, Washington, D.C., 1988

Diverse Works Gallery, Houston, Texas, 1988

Museum of Science and Industry, Chicago, Illinois, 1987

Studio Gallery, Washington, D.C., 1987

Fondo del Sol Visual Art and Media Center, Washington, D.C., 1985

The Tanner Gallery, Los Angeles, California, 1984

Evans-Tibbs Collection, Washington, D.C., 1983

Collections

Atlanta Life Insurance Company, Atlanta, Georgia

Maret School, Washington, D.C.

The Milwaukee Arts Commission, Milwaukee, Wisconsin

Biographies

Les Krantz, "Gail Shaw-Clemons," *Chicago Art Review,* 1989

Alice Thorson, "Trauma of Love, Fragility of Psyche," *Washington Times,* November 24, 1988

SYLVIA SNOWDEN

Painter, educator

Born 1942, Raleigh, North Carolina

Selected Studies

Howard University, Washington, D.C., B.F.A.,
M.F.A.

A Selected List

One-Person Exhibitions

"Paintings by Sylvia Snowden," M. Hanks
Gallery, Santa Monica, California, 1989

"Large Works on Paper," Brody's Gallery,
Washington, D.C., 1987

Group Exhibitions

"African-American Contemporary Art,"
Museo Civico D'Arte Contemporanea, Di
Gibellina, Sicily, Italy, 1990

"Introspectives: Contemporary Art by
Americans and Brazilians of African Descent,"
California Afro-American Museum, Los
Angeles, California, 1989

"Secrets," Gallery 10, Ltd., Washington, D.C.,
1988

"Afro-American Art, Now," The George
Washington University, Washington, D.C., 1987

"The Art of Black America in Japan,"
International Cultural Exchange Association,
Tokyo, Japan, 1987

"Works on Paper by Washington Artists," Jane
Haslem Gallery, Washington, D.C., 1987

"Myth and Ritual," Touchstone Gallery,
Washington, D.C., 1986

Collections

Hampton University, Hampton, Virginia

Howard University, Washington, D.C.

Biographies

Guy C. McElroy, Richard J. Powell, and Sharon
F. Patton, *African American Artists, 1880 –
1987: Selections from the Evans-Tibbs
Collection,* 1989

Alice Thorson, "Sylvia Snowden Engaging
Expressionism," *New Art Examiner,* October
1988

Elizabeth Lazarus, "The Experience Exhibited,"
Washington Post, August 24, 1986

RENÉE STOUT

Sculptor, educator

Born 1958, Junction City, Kansas

Selected Studies

Carnegie-Mellon University, Pittsburgh,
Pennsylvania, B.F.A.

<center>A Selected List</center>

One-Person Exhibitions

"Recent Sculpture," B R Kornblatt Gallery,
Washington, D.C., 1991

Chapel Gallery, Mount Vernon College,
Washington, D.C., 1987

Group Exhibitions

"Black Art—Ancestral Legacy: The African
Impulse in African-American Art," Dallas
Museum of Art, Dallas, Texas, 1989

Marie Martin Gallery, Washington, D.C., 1988

Carlow College, Pittsburgh, Pennsylvania, 1987

AT&T Building, Pittsburgh, Pennsylvania, 1986

"The Sixth Atlanta Life African-American
National Art Competition and Exhibition,"
Atlanta Life Insurance Company, Atlanta,
Georgia, 1986

Wayland House Gallery, Washington, D.C.,
1986

Museum of Science and Industry, Chicago,
Illinois, 1985

Collections

Allegheny Community College, Pittsburgh,
Pennsylvania

Dallas Museum of Art, Dallas, Texas

Biographies

Lee Fleming, "Casting Spells," *Museum & Arts
Washington*, March/April 1990

Robert V. Rozelle, Alvia Wardlaw, and
Maureen A. McKenna, *Black Art—Ancestral
Legacy: The African Impulse in African-
American Art*, 1989

DENISE WARD-BROWN

Sculptor, educator

Born 1953, Philadelphia, Pennsylvania

Selected Studies

Tyler School of Art, Temple University, Philadelphia, Pennsylvania, B.F.A.

Howard University, Washington, D.C., M.F.A.

A Selected List

One-Person Exhibitions

"New Work," Jones Troyer Fitzpatrick Gallery, Washington, D.C., 1989

"Assemblage," The "O" Street Studio, Inc., Washington, D.C., 1989

Group Exhibitions

"Next Generation: Southern Black Aesthetic," Southeastern Center for Contemporary Arts, Winston-Salem, North Carolina, 1990

"Other Rooms," The Kunstraum, Washington, D.C., 1990

"People Who Make Prints," Northern Virginia Community College, Annandale, Virginia, 1989

"Four Artists," Notre Dame College, Baltimore, Maryland, 1989

"Installations," Rockville Arts Center, Rockville, Maryland, 1989

"Bridges to the African-American Aesthetic," Strathmore Hall Arts Center, Rockville, Maryland, 1988

"Afro-American Art, Now," The George Washington University, Washington, D.C., 1987

Collections

Office of the Mayor, Washington, D.C.

Biographies

Curtia James, "Denise Ward-Brown," *New Art Examiner,* December 1989

Jo Ann Lewis, "The Myth Masters," *Washington Post,* March 1, 1986

JOYCE E. WELLMAN

Painter, printmaker, educator

Born 1949, New York, New York

Selected Studies

Maryland Institute College of Art, Baltimore, Maryland

University of Massachusetts, Amherst, Massachusetts, M.A.

A Selected List

One-Person Exhibitions

"Art in Public Places," Court House Square, Arlington, Virginia, 1989

"Metro Art Program," First American Bank, Washington, D.C., 1989

Group Exhibitions

"Saluting Ellington: Selected Works of Five Washington Artists," D.C. Commission on the Arts and Humanities, Washington, D.C., 1990

"From the Potomac to the Anacostia: Art and Ideology in the Washington Area," Washington Project for Arts, Washington, D.C., 1989

"Introductions," June Kelly Gallery, New York, New York, 1988

"Made by Hand: Works on Paper," Minneapolis College of Art and Design, Minneapolis, Minnesota, 1988

"Black Women Visual Artists in Washington, D.C.," The Bethune Museum-Archives, Inc., Washington, D.C., 1986

"1270 Women Art Exhibition," Metropolitan Museum of Art, Division of Community Programs, New York, New York, 1974

Collections

Evans-Tibbs Collection, Washington, D.C.

National Urban League, New York, New York

Biographies

Alice Thorson, "Common Bonds," *City Paper,* February 8, 1991

Rick Powell, *From the Potomac to the Anacostia: Art and Ideology in the Washington Area,* 1989

ADELL WESTBROOK

Painter, educator

Born 1935, Little Rock, Arkansas

Selected Studies

University of Maryland, College Park,
Maryland, B.A.

The Catholic University of America,
Washington, D.C., M.F.A.

A Selected List

One-Person Exhibitions

Henri Gallery, Washington, D.C., 1985

Group Exhibitions

Henri Gallery, Washington, D.C., 1985

"Art Experience Day," Montgomery College,
Rockville, Maryland, 1981

11th Annual Glen Echo Park Exhibition, Glen
Echo, Maryland, 1981

"Emerging Artists," The Art Barn Association
Gallery, National Park Service, Washington,
D.C., 1981

"Women's Tools," Washington Women's Art
Center, Washington, D.C., 1981

Salve Regina Gallery, The Catholic University
of America, Washington, D.C., 1980

Collections

The Catholic University of America,
Washington, D.C.